MW01474250

NEW SOUTH WALES

» IN PHOTOS «

NEW SOUTH WALES

» IN PHOTOS «

Tim Frawley

EXPLORE AUSTRALIA

» INTRODUCTION

I lived in southern Sydney for the first 25 years of my life. A place where the smell of sunscreen and having salty hair were the norm, as were weekend barbecues and barefoot cricket. You could say I was a beach bum, and to me, pristine beaches and an endless coastline was quintessential New South Wales.

Being a photographer encapsulates everything that I love: creativity, storytelling, appreciating beauty in the everyday and exploring far-flung places to quench my never-ending thirst for adventure. Travelling the world meant I could collect snippets of life and my journeys at a 100th of a second at a time.

Since returning, I have been exploring my home state. The further I venture, the more I fall in love with New South Wales and have realised that I don't need to board a plane to experience some of the world's most breathtaking scenery.

Investigating New South Wales for this project, I visited the moonlike landscapes of Mungo National Park, took Europeanesque glacier hikes in the Snowy Mountains, got lost in unique bushlands packed with flora and fauna and met hardy outback Australians I swear could be Ned Kelly's relatives.

As you flick through *New South Wales in Photos* you will also experience the state's diversity and see places of staggering beauty that were in my backyard all along.

Whether you are on the hunt for adventure in the mountains, eager to experience the uniqueness of the outback, want to laze about on beaches or explore the splendour of one of the state's many national parks, you will never be bored in New South Wales.

TIM FRAWLEY

» **LEFT** Exploring 32 kilometres of pristine beaches in Worimi Conservation Lands

» **PREVIOUS** The iconic Bondi Icebergs Pool on a busy summer's day

» **ABOVE** An outdoor toilet at the historic Zanci homestead, Mungo National Park

» **RIGHT** No shooting at a property in Glen Davis, Central Tablelands

» **OPPOSITE** A vintage opal mining blower truck in White Cliffs

» **ABOVE** The Bondi Beach Sea Wall showcases artworks by local and international artists

» **LEFT** The colourful Mitchies Jetty at Merimbula

» **OPPOSITE** A power pole in Tathra adorned with hundreds of lost thongs

» **OVERLEAF** Wandering among the dunes of Worimi Conservation Lands, the largest sand-dune system in Australia

008

» **ABOVE** A Newtown garage receives a colourful facelift

» **OPPOSITE** The Art Deco façade of the Newcastle Ocean Baths

» **ABOVE** Taking in the dramatic views of the Blue Mountains

» **RIGHT** Leaping off Wattamolla Falls into a crystal-clear lagoon

» **OPPOSITE** A wallaby and her joey at Dunns swamp–Ganguddy campground in Wollemi National Park

011

» RIGHT Daily commuters traversing the 180 metre Wynyard Walk in Sydney

» **ABOVE** A surfer enjoying an empty line-up at Garie Beach, Royal National Park

» **OPPOSITE** Midday sun filtering into the Dry Canyon at Newnes Plateau

» **ABOVE** Early morning traffic crossing the Sydney Harbour Bridge

» **OPPOSITE** Feeling on top of the world at the Snowy Mountains

» **OVERLEAF** The mystical yet eerie waters of Dry Lake which is scattered with hundreds of dead trees

» **ABOVE** Young cowboy in the making at Goulburn Rodeo

» **LEFT** Adventure touring on the outskirts of Lithgow

» **OPPOSITE** A cowboy warming up for a Goulburn Rodeo breakaway roping event

» **ABOVE** Local artists regularly demonstrate their skills at Pitt Street Mall in Sydney's CBD

» **RIGHT** The entrance to St James, Australia's first underground train station

» **OPPOSITE** A street performer entertaining the lunchtime crowds in Sydney's city centre

» **ABOVE** Sandboarding wipe-out at Stockton Sand Dunes

» **OPPOSITE** Afternoon longboard session at The Pass, Byron Bay

» **OVERLEAF** Autumn colours spreading over Blackheath

» **ABOVE** A car that featured in the *Mad Max* films outside The Silverton Hotel

» **LEFT** An abandoned petrol station left to deteriorate outside White Cliffs

» **OPPOSITE** One of many tin shacks constituting Tin City on Stockton Beach

» RIGHT Watching the game at a giant chessboard in Hyde Park in Sydney

» **ABOVE** Street art at Spice Alley, Chippendale

» **LEFT** A painted outback dunny at Silverton

» **OPPOSITE** A lone cow awaits an oncoming summer storm in Rylestone

» **OVERLEAF** A summer's Sunday at Bondi Beach speckled with 100s and 1000s

033

LEFT A fly fisherman trying his luck in the tranquil waters of the Thredbo River

» **ABOVE** Frosty nights at Boyd River require campfires to keep warm

» **RIGHT** Collecting firewood for campfire cooking at Jenolan State Forest

» **OPPOSITE** Sunset over dramatic pagoda rock formations at Wollemi National Park

039

» RIGHT A Goulburn shearer finishes off the last sheep after a long hot day

» **ABOVE** The bright colours of canola surround lone trees near Canowindra

» **OPPOSITE** Patchwork canola fields of Cowra

» **ABOVE** Opera House pavlova, a special dessert offering at Bennelong Restaurant

» **RIGHT** A rainbow lorikeet enjoying some kangaroo paw in Sydney's Royal Botanic Gardens

» **OPPOSITE** Sydney's two biggest icons spotted from the Royal Botanical Gardens

» **ABOVE** The *Mad Max* Museum at Silverton

» **OPPOSITE** A road train embarking on one of the many long straight roads between Cobar and Broken Hill

» **OVERLEAF** Morning sun illuminating the ridges of the Blue Mountains and the Three Sisters, Katoomba

» **ABOVE** A hidden secret of the Sapphire Coast, the Pinnacles are a vibrant, alien-like geologic formation

» **LEFT** One of the handful of year-round opal miners at White Cliffs

» **OPPOSITE** The Tacking Point Lighthouse perched over Lighthouse Beach, Port Macquarie

» **ABOVE** The tropical canopy of Nightcap National Park

» **RIGHT** When hiking in the Warrumbungles, you'll run into creatures of all shapes and sizes, especially lizards soaking up the sun's heat

» **OPPOSITE** Little adventurers exploring the Minnamurra Rainforest Walk

» **RIGHT** Low-budget accommodation in the opal fields of White Cliffs

» **ABOVE** Admiring the sunset over Lake Mungo

» **OPPOSITE** The Mona Vale ocean pool sits on a rock platform separating Mona Vale and Basin Beach

» **OVERLEAF** Starry outback skies over an old shearing shed at Mungo National Park

» **ABOVE** Soaking up the afternoon sun at Newcastle Ocean Baths

» **RIGHT** A surfer heads out for some afternoon waves at Port Macquarie's breakwall

» **OPPOSITE** Anyone can add to the breakwall's painted rocks that line the Hastings River

» **LEFT** Wandering the streets of Wollombi is like stepping back in time to the 1800s

» **OPPOSITE** The criss-crossing escalators inside Sydney's lavish Queen Victoria Building

» **ABOVE** Paddling around Royal National Park is the best and most relaxing way to explore all its beauty

» **OPPOSITE** At 90 metres tall, the jagged Breadknife (a volcanic dyke) towers over Warrumbungle National Park

» **OVERLEAF** A common sight while driving the red dirt roads around Mutawintji National Park

» **ABOVE** Coonabarabran residents trying to out-letterbox each other

» **OPPOSITE** Roadside shop selling local produce using the honesty system for payment

» RIGHT Locals and tourists doing laps at Sydney's Bondi Icebergs Pool

» **ABOVE** Thousands of cotton bails rolled and ready for export on the outskirts of Griffith

» **LEFT** Cotton bails are a common sight when driving the roads around Griffith

» **OPPOSITE** A lone farmer in Darling Point ploughs his fields in preparation for next season's crops

» **OVERLEAF** The enchanting beauty of the Sugar Pine Walk

» LEFT 'Bin chicken' street art in a Sydney backstreet

» **ABOVE** Winter snow starts to melt, welcoming spring to the Snowy Mountains

» **RIGHT** The morning sun catching the ever-changing shapes of Stockton sand dunes

» **OPPOSITE** Sunsets in the Kanangra–Boyd National Park never disappoint, attracting photographers, hikers and tourists from all over

» **OVERLEAF** A legendary landmark, the Harbour Bridge delivers the best views in Sydney

» **LEFT** Mustering cattle on a farm in Fullerton

» **RIGHT** Outdoor dining in Spice Alley, tucked away in busy Chippendale

» **OPPOSITE** Suspended birdcages of the *Forgotten Songs* installation at Angel Place in Sydney's CBD

» LEFT Chilling out at Oxley Beach, Port Macquarie

» **ABOVE** The heritage Zig Zag Railway tracks hug the Blue Mountains

» **RIGHT** Prayer flags hanging outside a house in Nimbin

» **OPPOSITE** Relaxing in nature at Capertee Valley; a great way to unwind

LEFT Sunrise over Cape Byron, Australia's most easterly point

» **LEFT** The golden light of sunset hitting Kanangra Walls

» **OPPOSITE** Dead trees contrast the living in Kosciuszko National Park

» **ABOVE** Splendid winter sunrise over Jindabyne

» **OPPOSITE** Flowers on the shores of Lake Jindabyne making their first appearance since winter

095

» ABOVE Braving the wild seas as they lash Nobbys Breakwall
» OPPOSITE Boats speckling the blue waters of Nelson Bay

» **ABOVE** Minyon Falls drops more than 100 metres into a deep gorge surrounded by a thriving rainforest

» **RIGHT** A curious bush turkey gets up close and personal in Wollumbin National Park

» **OPPOSITE** One of NSW's most spectacular waterfalls, the three-tiered Wentworth Falls

» **OVERLEAF** The rustic remains of a farmhouse near Hill End

» **ABOVE** Early morning start at Bronte Baths
» **RIGHT** Locals only at Tin City
» **OPPOSITE** Taking on the wild seas at the Bogey Hole

» **ABOVE** Afternoon laps at Newcastle baths
» **OPPOSITE** Goulburn shearers lay out freshly shorn wool

» **ABOVE** The Walls of China in Mungo National Park, possibly the most spectacular outback landscape in New South Wales

» **LEFT** The vibrant red stairs of 1 Martin Place, Sydney

» **OPPOSITE** A bird's eye view of the Hunter Valley Gardens

» RIGHT A fisherman sits on striking red rocks synonymous with the Sapphire Coast, in front of folded metamorphic rocks

» **ABOVE** A White Cliffs miner showing off one of his prized opals
» **LEFT** Colourful carnival games of Luna Park, Sydney
» **OPPOSITE** An aerial view of White Cliffs' opal mines resembles an Indigenous Australian painting
» **OVERLEAF** Sydney Harbour sparkles with colour at the annual Vivid Sydney Festival

» **RIGHT** A group hiking along the undercliff track at Wentworth Falls

» **OPPOSITE** The Sea Cliff Bridge; perfect for putting the top down and exploring the South Coast

Published in 2018 by Hardie Grant Travel,
a division of Hardie Grant Publishing

Hardie Grant Travel (Melbourne)
Building 1, 658 Church Street
Richmond, Victoria 3121

Hardie Grant Travel (Sydney)
Level 7, 45 Jones Street
Ultimo, NSW 2007

www.hardiegrant.com/au/travel

Explore Australia is an imprint of Hardie Grant Travel

All rights reserved. No part of this publication may be reproduced, stored in a retrieval system or transmitted in any form by any means, electronic, mechanical, photocopying, recording or otherwise, without the prior written permission of the publishers and copyright holders.

The moral rights of the author have been asserted.

Copyright text and photography
© Tim Frawley 2018
Copyright concept and design
© Hardie Grant Publishing 2018

A catalogue record for this
book is available from the
National Library of Australia

New South Wales in Photos
ISBN 9781741175462

10 9 8 7 6 5 4 3 2 1

Publisher
Melissa Kayser

Project editor
Megan Cuthbert

Editor
Karen Tait

Editorial assistance
Aimee Barrett and Rosanna Dutson

Design
Erika Budiman

Typesetting
Megan Ellis

Prepress
Megan Ellis and Splitting Image Colour Studio

Printed in China by 1010 Printing International Limited

» **COVER TOP & BACK COVER** Bondi Beach speckled with 100s and 1000s

» **COVER MIDDLE** A hay bale cowboy just outside of Dubbo

» **COVER BOTTOM** Surfers at Port Macquarie